Fred Martin
From Paintings and Notes 2010

The places

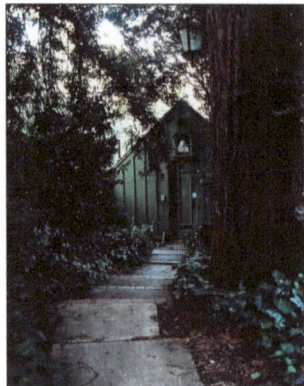
The Path to the Monte Vista Studio

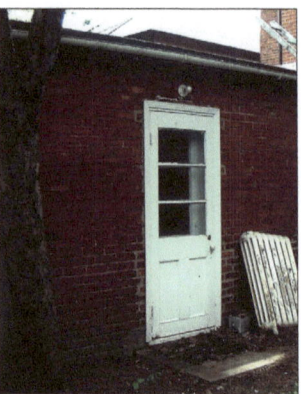
Doorway to the Montreal Studio

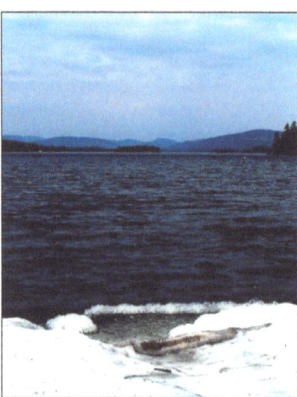
Lac Ouareau, a winter evening
before the lake freezes.

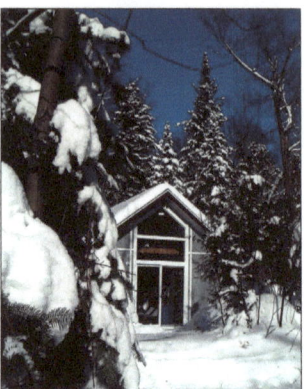
Lac Ouareau Studio

I have generally noted in the following pages the places where the work was made, partly because it helps me to keep track of the times and places of my own life, and partly because the character of a place affects the work made in it... to feel the position and scale of the work in the studio in relationship to the location and scale and movement of my body, and to sense the body's resonance to the space of the studio and the studio's place in the space of the world.

For my wife, Stephanie

©2011 Fred Martin

pub Lulu.com for
Green Gates Press
#116, 4096 Piedmont Avenue
Oakland, California, 94611.
USA

isbn
978-1-257-01907-6

Fred Martin
From Paintings and Notes 2010

pub Lulu.com for
Green Gates Press
2011

Fred Martin, from Paintings and Notes 2010.

By Way of Introduction.
Two letters and a note to myself from the mid to late 1950's.

A letter to Leo Castelli….[1]

If talk has been closed off for a long time and if insight and awareness have been bottled up inside oneself for years, they curdle. When the bottle is poured, not much comes out. I have been painting here on the ragged edge of the West and of death for ten years. During the last seven years there has been no communication and no response. In that time, of course, the river of making, eager to become an ocean, has been perforce compressed and distilled, endlessly concentrated and funneled, ever narrowed and reduced toward the indestructible and the worthless.

In this effort toward the indestructible—sure, the "authentic"—the peculiar arises, and there comes too an awareness of the worthlessness of this indestructibility, of the proper no value of it to the rest of the world. I have come to know that the *aqua vitae* was thrown away in the street and so I must throw away upon the world those bottles in which I have sometimes caught it. They achieve value only if found casually and unexpectedly on the horizon of comprehension.

As souvenirs of an evening lived out on the horizon, you will find enclosed several fragments of the tree which nurtures itself in living water. There is a splinter from the root, and a yellowed leaf from an upper branch. Feel free to throw them away.

Sincerely,
Emil Sinclair

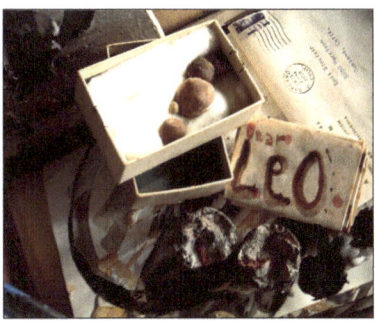

The box of *Immortality Pills* for Leo Castelli.

[1] Sam Francis had told me that Castelli was starting a gallery and looking for new art—Rauschenberg was an example—and Sam knew I had made some sculptures out of scrap lumber and other trash from our basement. David Park had told me that William Saroyan had sent a story to the same magazine every week until they finally published one. I tried that with Castelli, using the name Emil Sinclair—Hermann Hesse's nom d' plume for his novel *Demian*, and the name of the early 19th C. German Romantic poet Hoelderlin's caretaker during his schizophrenia. Finally the gallery assistant sent one back with a note saying "Mr. Castelli says, 'Stop.'" The item was the *immortality pills* above.

Fred Martin, from Paintings and Notes 2010.

A letter to the editor of *Art News*...
Dear Tom: (Hess)[2]
I might have determined some years ago to take an active part in the affairs of the great world, and might have set out to be a great artist in the contemporary convention of such. But a little bit of fear, a little bit of inadequacy, and a little bit of the smallness of my origins leading to a predisposition to envy and shallow self-pity has brought it about, in conjunction with certain events in the external world and certain commitments which I had made to the lives of others, that I elected to become ordinary, dull, and bourgeois.

However, there is available to us another way of looking at these things: we might, rather than using the common negative description of all human acts (always placing them in the light of their lowest common denominator, the furry little fornicator dwelling in us all), take a comparatively uncommon view that, although we are each individually responsible for all of our acts, those acts do not necessarily stem from weakness (no matter how weak they might appear to be). Thus we could assume that a failure to cast off common bourgeois attachments, a failure to travel to the capital to seek our fortunes in the great theater of time and of humanity—the failure to fight it out in the casting-office for a part in the history-play of the world—might stem not from cowardice or weakness but rather from a clear sighted awareness of what is independent and free.

Therefore it could be in the search for authentic life, that a life could be built here on the far Western edge and could even make art as an aspect of its building, and the art so made would be of such a nature as to stand aside from time as it appears in the mass images of the day and would instead dance on the beams of the radiant sun of eternity.

One of the most important things for us to remember is the difference between art and life. We talk frequently of this and it was made once into the root-idea of abstract art. However, we continually mix ourselves up with various literary characters until finally we see ourselves as the William Blakes or Vincent Van Goghs appear in biographers' discussions, or as the historical forces of genius appear in the philosopher-historians' analyses of history.

It is true that we quite naturally tend to form ourselves upon the various images of a possible life as they are presented to us in the accounts of the lives of others, but it is also true that we are not as careful as we should be in separating from those accounts the events and the viewpoints which their authors add in order to make interesting reading. Thus we are often led to the attempt to lead a perfectly impossible life—even sometimes a perfect parody of the authentically possible— in the effort to find and fulfill a vital model for our own lives. And so we begin to make for ourselves a life which might make interesting reading in the hands of a romantic novelist, but in terms of authentic human life it is only a miserable abortion.

[2] Hess had coined the now common term "Abstract Expressionism" for the new art of the late 1940's-early 1950's . This letter was probably written 1955-56, but never sent.

Fred Martin, from Paintings and Notes 2010.

Undated late 1950's, a studio note to myself.
It is my task to make the image, to set the silence of the day to singing in far spaces, to send its light quivering yet still across the plains and seas and mountains and into the sky of the day. I am the mirror, I reflect the storm and know the quiet of its center.

But most of all, in paying attention to life—that is, in noticing its look and in speaking calmly and surely of it—may I begin to assume that being which I seek. And I think that I will find myself to be crossing the Western borders of Zhou[3] and so to begin the so long heralded ascent of the Sun.

Some of the paintings of those days looked like this—

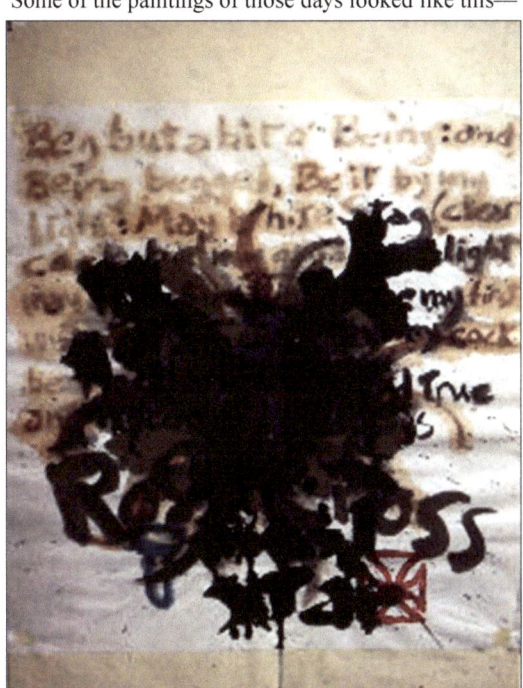

Beg but a bit o' Being...
Watercolor and distemper on rice paper mounted on oatmeal paper.
approx.. 30 x 20 inches.

[3] A reference to Ssu-Ma Chien's history of Lao Tze's departure from Zhou into the lands of the west, and, at the gates of departure, the Gate Keeper's request for Lao Tze's philosophy (which became the *Tao Te Qing*).

Fred Martin, from Paintings and Notes 2010.

And now for work in 2010

February 12, 2010.
Monte Vista, very early morning.
I heard as I woke this morning, "Theirs was a project to fix broken bridges, and because in time every bridge will break they always had work."

February 13, 2009.
Monte Vista, night.
I date my work and send it as a message in a bottle thrown from a desert island into the ocean of time. Some far place and time it may wash up on a beach and be opened. People will read the note and say "They're all dead," leaving the bottle broken and the message lost in the sand.

NO! I don't want that. If the message is worth sending (I have faith and believe that it is), I will say it now.

February 14, 2010.
Monte Vista, late afternoon.
Noticing more notes to transcribe, and thinking about my journal of passing thoughts, I heard "That is the base..." and in a transcription of the 2008 December notes I found...

> **December 16, Monte Vista, 1:30 am..**
> Looking at the studio[4]—alright, it's the scholar's study. And what is the scholarship? Human life. And where is the study? An artist's studio.
> Find your way, find your way.

> **December 26, Monte Vista, early am..**
> I have no product (paintings), only thoughts. Thought is a product of life. Follow the Chinese, make not paintings but calligraphies.

Looking at all this of this afternoon, the studio, the work on the table, the desk... Yes, that is studio work. It may not be painting, but it is studio work.

February 16, 2010.
Monte Vista Studio, night.
Trying to make sense of it—a life's work.
Oh, it makes sense alright, it's only that I don't want to know what it is.

February 22, 2010.
Montreal, morning.
I heard, "All is broken and long gone..." It was a song and after those words came a dying chord in a wordless chorus. I have never been given to depression. Now, is that this?

[4] In 2008 the Monte Vista studio was in the house.

Fred Martin, from Paintings and Notes 2010.

**February 25, 2010.
Montreal studio, night.**

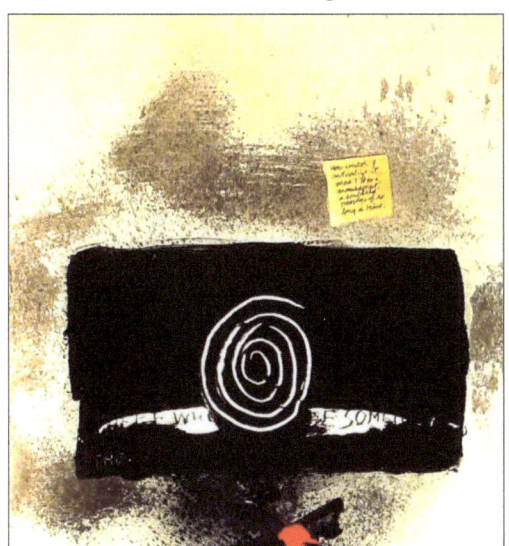

#5 February 2010.
Acrylic on paper with collage, 22x 15 inches.

At a loss for what to make, I wrote "There will be something," and then put a thick black smear over it. I remembered the red spiral in ***#3 February*** (next page), and decided to fulfill the ***#3 February*** spiral by cutting it into the black and then cutting through the black to the words "There will be something." Then I wiped the black off the knife to make the four directions and put in the red core.

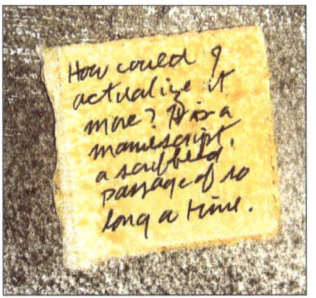

A week or two later I added the note: "How could I actualize it more? It is a manuscript, a scribbled passage of so long a time."

Fred Martin, from Paintings and Notes 2010.

February 23, 2010.
Montreal Studio, night.
Bad news coming, bad news come
How much pain can you take
before the end.

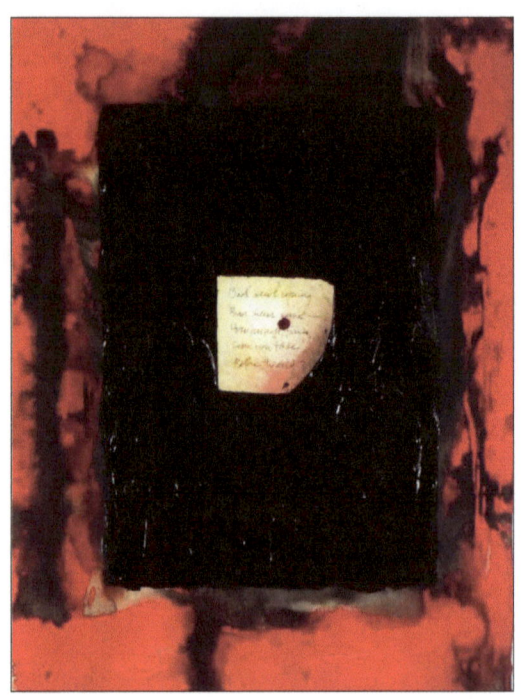

#2 February 2010.
Acrylic on paper with collage, 22x 15 inches.

It says the above.

Fred Martin, from Paintings and Notes 2010.

February 24, 2010.
Montreal Studio, afternoon.
I heard…
"What more do you want for your sadness; what more would you have for the darkness in our lives?"

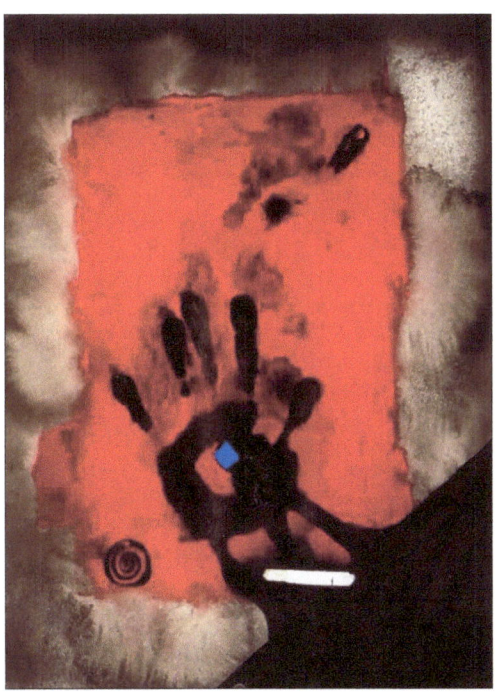

#3 February 2010.
Acrylic on paper with collage, 22x 15 inches.

Working on *#3 February*, I saw…
"He's running, but he won't make it."

And then I gave the Death Hand a blue star of spirit in the palm.

Night.
And to the runner I gave a dust mote of eternity which the image made to become a streak of blood sperm—that's the black blot with the red spiral—and is not that our only way beyond time?

Fred Martin, from Paintings and Notes 2010.

March 22, 2010.
Lac Ouareau studio, afternoon.
Re-worked *#9 February 2010* into becoming *#2 March 2010*. The *#9 February* was never satisfactory. Now I think it's great. It's the life story from conception to the living of life to end in the blue of spirit in the death star. But it is also a self portrait of whoever looks at it—as Thomas Puttfarken says in his *The Discovery of Pictorial Composition*, "Of unchanging aspect, centralized and frontally intended to the viewer, the bounded image offered *a priori* a formal structure that corresponded precisely to the demands and the functions of the cult image."

This morning I had been looking in a mirror at my cock and torso and thinking about how that—my cock especially—has always been my personal cult image. With this painting, though, when hung on the gray wall in the studio at the height it is now, and when I look straight at it, the red line with the white sperm dot in the black stroke near the bottom is about at the level of my crotch, the red dot with the white spiral of life opening out from it at the center of the painting is directly in front of my heart, and the black haze with cobalt blue diamond is where my head is. Yes, the distances are not exact. But as when looking in a mirror (like me and my torso as cult image in the bathroom mirror this morning), look in this painting and see yourself not as others may see you, but as you are—birth, life, spirit, all three all the time.

"Of unchanging aspect, centralized and frontally intended to the viewer…"[5] Yes, that's this painting hanging here now on the gray wall in the studio, although, having this last week read a good deal of Puttfarken's book, I don't think he would recognize it.

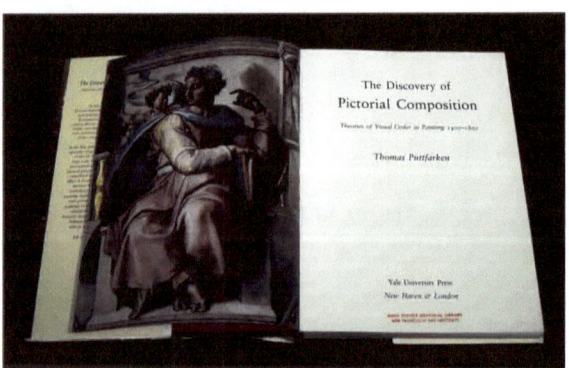

Thomas Puttfarken: The Discovery of Pictorial Composition
Theories of Visual Order in Painting 1400-1800
Yale University Press, New Haven and London, 2000.

[5] See Puttfarken, p. 32

Fred Martin, from Paintings and Notes 2010.

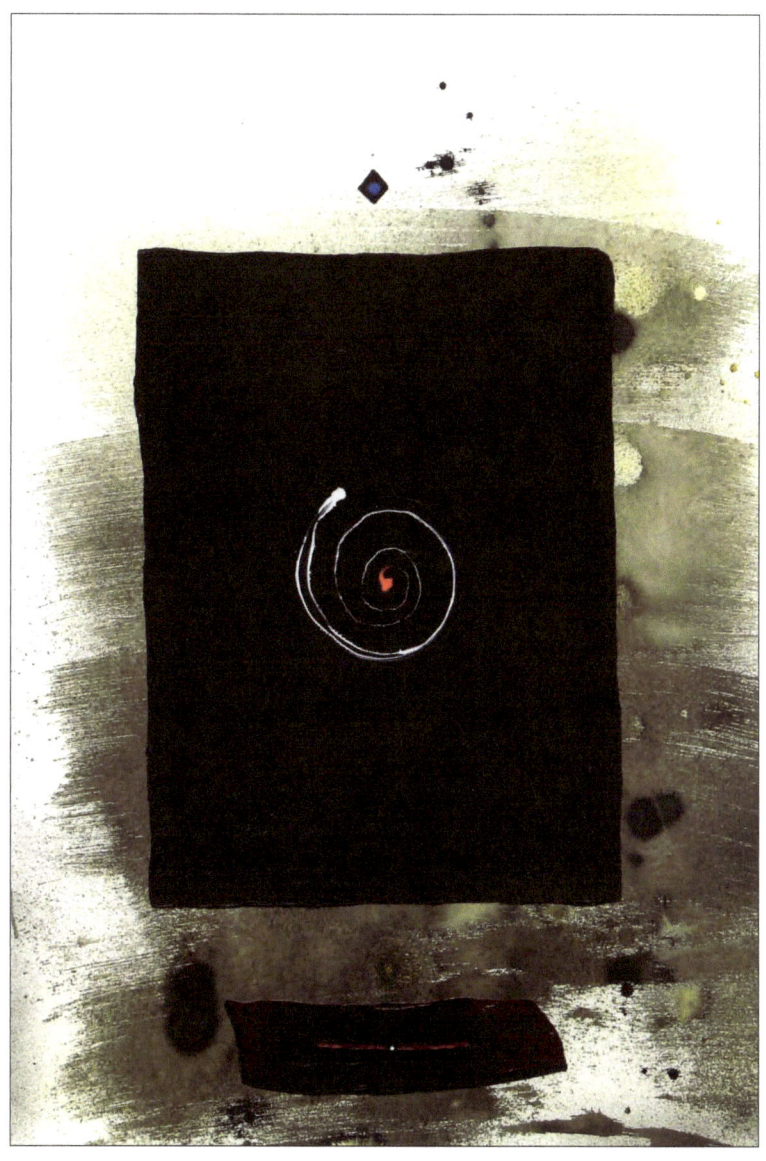

#2 March 2010.
Acrylic on paper, 44 x 30 inches.

Fred Martin, from Paintings and Notes 2010.

April 2-7, 2010.
Lac Ouareau studio, late afternoons and evenings.
Having read Vikram Seth's *Three Tang Poets*, and noting that the poems of Tu Fu were only collected many years after his death and that many were surely lost—and remembering that in my undergraduate Chinese poetry course sixty years ago Tu Fu was one of my favorite poets, I decided to transcribe all of my I-phone voice memos from August 2009 through March 2010 and to select from them to make my own collection of the lost poems of Tu Fu...

1. We each must do what each of us must do in our authenticity.
2. It is a very strange and downward trip, but it is that. Do as you did with every other trip, watch, save, mark, send—watch you, save you, mark you, send it.
3. The stuff is all there—the material—waiting for the summing up.
4. Oh how far we've gone, oh how much we've done—all the hunger and the hope.
6. Oh tell us, tell us how to go; tell us, tell us how to know.
7. Oh, come with me, come with me there. Oh, go with you, go with you where?
8. You have to make it past from the here to the summing up. Shit.
5. For the summing up before it comes, do it now to know how to do it then.
9. Oh, man, these days with their piercing light, low sun, long shadows...
10. Leave me alone to find my fate. That's it.
11. With regard to tonight's painting, now it's later up against a very hard wall.
12. What will I do, how will I know, where will I go?
13. So it goes, night follows day, and so it does. You cannot keep the lights on all night long.
14. What will it be and how will it go? From where to where, and after there?
15. They are messages sent from so long ago to so far to come.
17. Tamalpais, the far peak, the Indian maiden always calling to the far beyond.
18. Where will you go, how will you get there? What will you do, what will you become?
16. There is only one theme there—old age, loss, death. That's all there is. Once too much testosterone. Now, though, only fading, failing, leaving, gone.
19. So, you're dying. What's left to make, and who's left to look? It's always been a lesson but there are no hearers any more.
20. It always told me the task, seeing the sunrise. Now I see the sunset.
21. In this world of wreck and ruin, of break and no repair, how to find that which does not and is ever true.
22. What to save when no one wants it, washed away in the sea of time.
23. I am afraid of the dark.

All genuine by my seal.

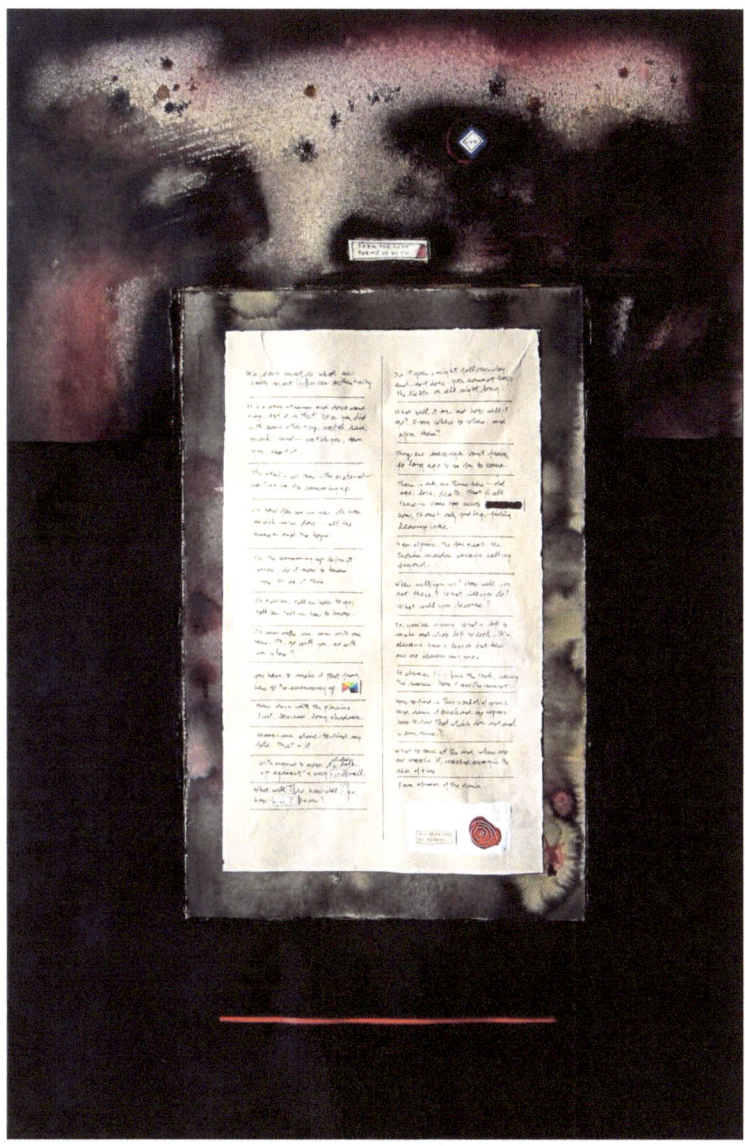

#1 April, 2010.
"From The Lost Poems of Tu Fu."
Acrylic on paper with collage. 40 x 30 inches.

Fred Martin, from Paintings and Notes 2010.

May 8-9, 2010.
Lac Ouareau studio, nights.
Make *#1 May 2010.*
From the drawings in the folder of *1956-57 Very Early Collage-Landscapes in Transition*, my 1957 experiences of the decrepit and abandoned pre-earthquake and fire old mansions of the Dolores and Western Addition neighborhoods of San Francisco that have been here on the studio wall this last two weeks, I made *#1 May* and heard, "A boy's got to do what a boy's got to do."

May 10, 2010.
Lac Ouaureau studio, afternoon.
Come back to see *#1 May 2010*...
OK, the studio is for the dark—as in Frank Barron on the Unconscious in his *The Shaping of Personality: Conflict, Choice and Growth* (Harper and Row, 1979)— and yes, like I saw last night, *#1 May* is a self portrait. Although not the me in the *1956-57 Very Early Collage-Landscapes in Transition* as I had consciously intended last night, but the me now as I looked last night at the me of 1957. I saw last night that the only way forward—I have been thinking of so many ways these last two weeks—was to stop looking and thinking about ways to build a collage out of all of the 1957's, but just to go "haptic" as I had at the end of *#2 April* when it seemed that was the only way to get to anything. And so, last night, that is what I did.

And now come into the studio to look at the results...
When I came in here and looked at it, I felt the urge to open my shirt and pants so the mirror—that's the painting—could see me and I could be what it shows... and if more work were to be done, to do it here now with the hungry fact of my flesh against it.

Well, I kept my clothes on as I put the painting up on the wall and the painting showed it wanted the sperm stroke in the foundation. And I heard that what the painting shows is, "Blood makes sperm in the house of the life of the body." I put the sperm stroke in the base. It's all risk to get it right the first time because there can be no second; but I didn't get it right, there had to be a second.

And so now it has become the womb with egg and sperm and embryo and all and everything.

You've got to stop fussing it so much. Let the intensity of the whole overwhelm the inadequacy of the parts.

Looking now, two hours after I started, where am I now? The painting is probably a wreck. I think when it's dry, take out the sperm line in the base, and replace it with the motif of the red bar with black spray and single red line with traces of white engraved in it (the sign of the fertilized cunt).

Night.
I came back to see it. The painting is finished.

Fred Martin, from Paintings and Notes 2010.

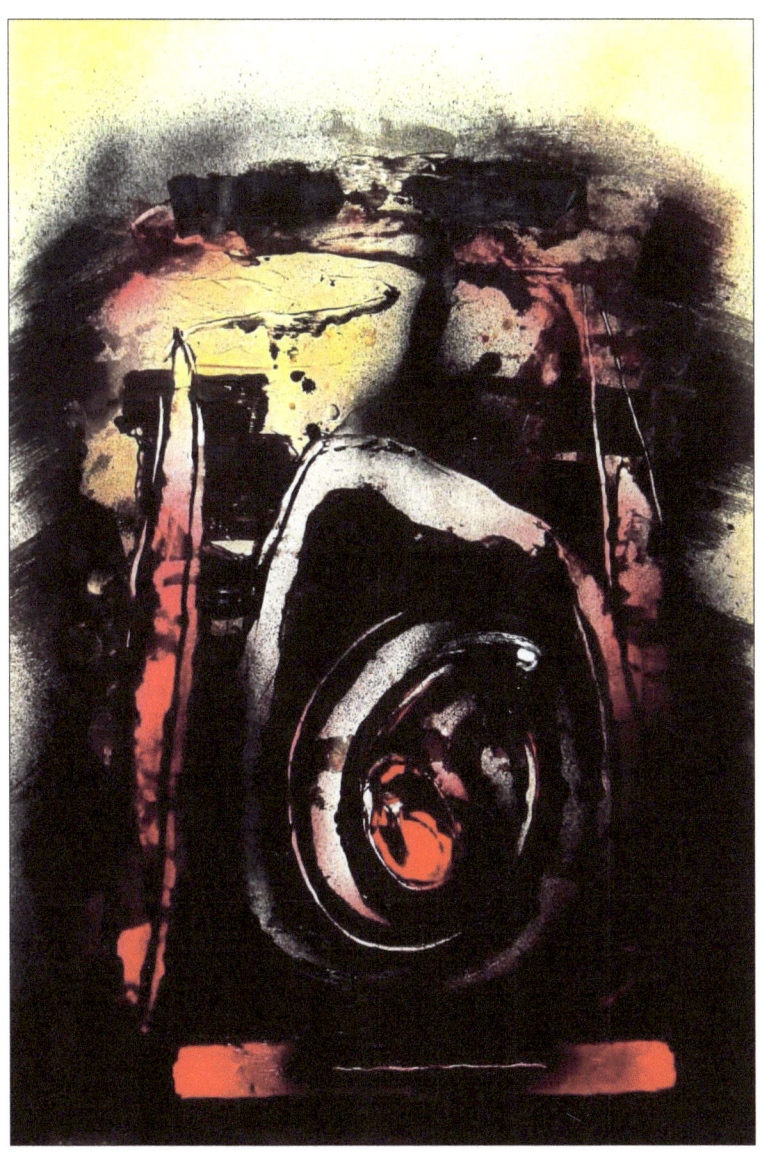

#1 May 2010.
Acrylic on paper, 44 x 30 inches

Fred Martin, from Paintings and Notes 2010.

May 23, 2010.
Lac Ouaureau, late afternoon.

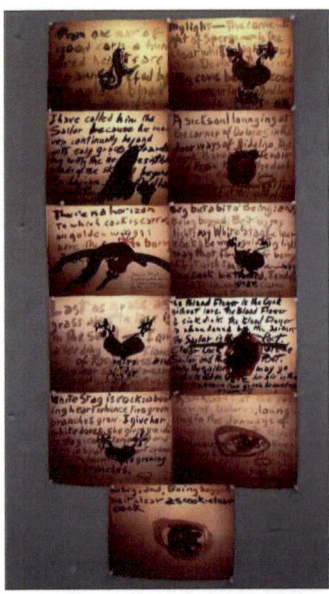

Continue with signs and symbols, images and themes from long ago…

Photoshop the 1958 *From One Ear of Good Corn* series (includes *White Stag* group), and pin up on studio wall in the same manner as the *Cock Book* group had been for making *#1 May*. Try to make a new from the old. What's it say? Shut up and wonder.

Night.
Looking at these on the wall, and thinking/feeling all the fifty years of my life since—well, it (my cock) did all that…

A note about method…
Start with something from the original, let the new media and scale make the then become now and reveal new images.

Finally, I started with the "From one ear of good corn…" at top of the left hand row.
What I got was *#3 May* on the facing page.

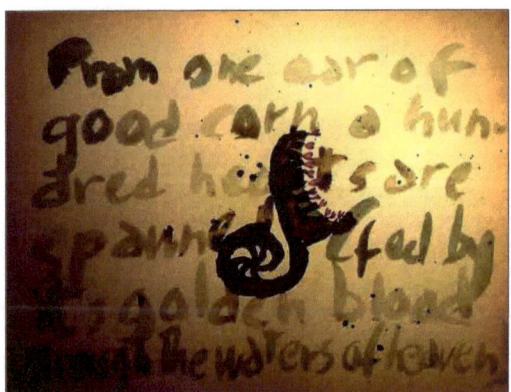

The text reads—
From one ear of good corn a hundred hearts are spawned
(fed by its golden blood through the waters of heaven)

Night.
Make *#3, May 2010* from the *From One Ear of Good Corn* image.

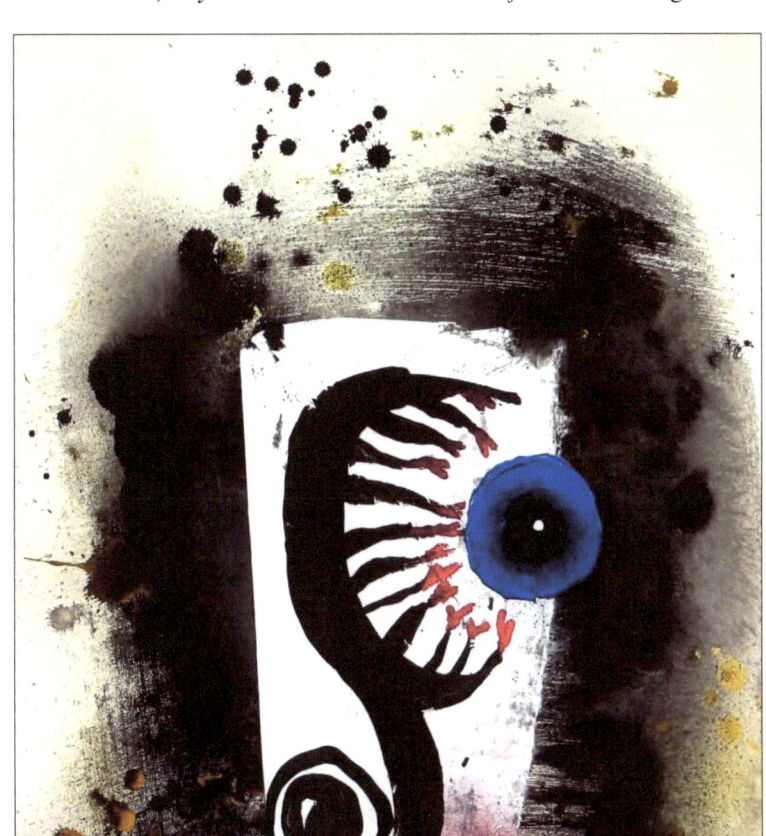

#3 May 2010.
Acrylic on paper with collage, 40 x 27.5 inches.

Fred Martin, from Paintings and Notes 2010.

June 7, 2010.
Lac Ouareau, morning.
Thinking about it, whether to go on or not with this work that has no place in the art world… It is only for me to decide, and I decide yes.

With my knowledge now half a century more than my knowledge then, to re-visit the 1950's works and their sources in order now to make their "summing up." I like the new work very much. And as for the art world, this work is for my "summing up," not its.

June 9, 2010.
Monte Vista, early morning.
I thought of it a few days ago, the way to work now—
Wondering about the clearest way to say the way that I am working now, it is from now to look at then with all the half century of life since.

June 11, 2010.
Monte Vista, Night.
Found some notes this afternoon, evidently from some time around last Easter…

>I didn't learn anything.

>Painting is learning, but I only played chess with what I already knew.

>The only learning was late last night from the leaves blown across the studio threshold. Now, after three days of the most intense work, all I got was a new sign for what I already knew.

>It is the nature of the job: keep on digging—that means looking.
>"Every day is new." What's this "new" crap? That's the way they sell "all new" models of cars.

>That is the way it goes: all things turn and turn again.

Notes from this afternoon…
Living in paint—a game of hope, discovery and regret.
Of becoming, of being and loss. To become, to be and to lose.

June 20, 2010.
Monte Vista, early morning.
Things break, few are repaired
Time eats, nothing is spared.

Fred Martin, from Paintings and Notes 2010.

June 24, 2010.
Monte Vista, night.

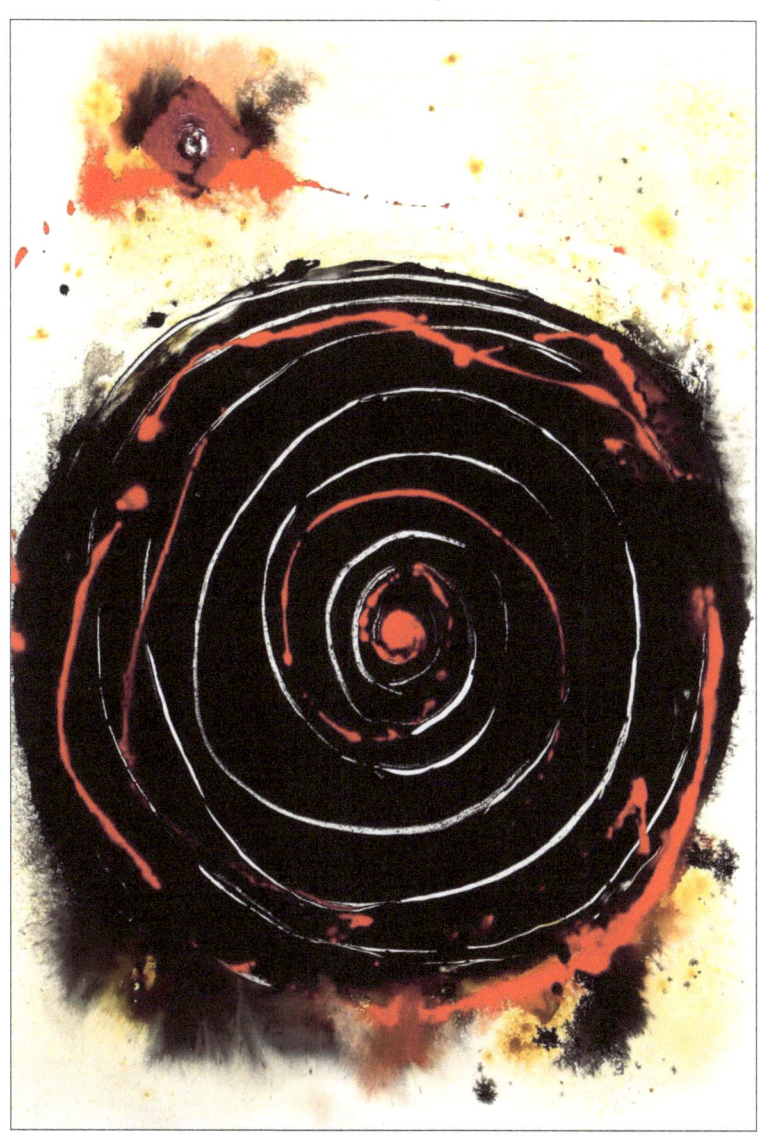

#1 June, 2010.
Acrylic on paper, 44 x 30 inches.

#1 June is life and death always together in the spiral of time.

Fred Martin, from Paintings and Notes 2010.

July 7, 2010.
Lac Ouareau studio, late afternoon.
Begin *#1 July 2010*.

1. Set the stage—the studio is a cathedral with high, pointed roof and tall windows revealing the sky. Examples are the Chinese, Hindu, and Buddhist temples, the Christian churches and the Islamic mosques.

2. Prepare the tools

3. Begin the ritual to invoke God.
(Shit, He's still in my crotch, the core of life and death, and it's watching the death part rise that's so…)

Turn on the lights focused on the painting table (the altar)—see the paper—oh my God, it's so BIG.

It's the image of the egg so vast, the sperm so small… (See July 8 below for completion of the sentence.)

Evening.
I thought/saw—
The stems and leaves of dry grass, and the green seed embedded at the crest of each stem… and as an old dry stem I should keep teaching to save the green seeds.

Night.
Waiting for *#1 July* to dry, reading the notes from years past that are in the computer, then looking at *#1 July*, I heard—

"Oh, it is so enormous (my work)." And writing this and looking at the egg in *#1 July*, I think yes.

July 8, 2010.
Lac Ouareau, late morning.
Completion of the July 7 note about *#1 July*…
The July 7 note began—"It's the egg so vast, the sperm so small…" The July 8 continuation is, "the end so sure." And so I decided to cover the meaningless blots and stains at the lower left of the egg with a white ribbon carved with the death cross.

Late night.
The death mark dry, demands the smallest drop of wet red at its center: new life always comes.

So late it's already tomorrow.
Sure new life always comes, but it will not be me.
[Fading away, I hear me squealing…]

Fred Martin, from Paintings and Notes 2010.

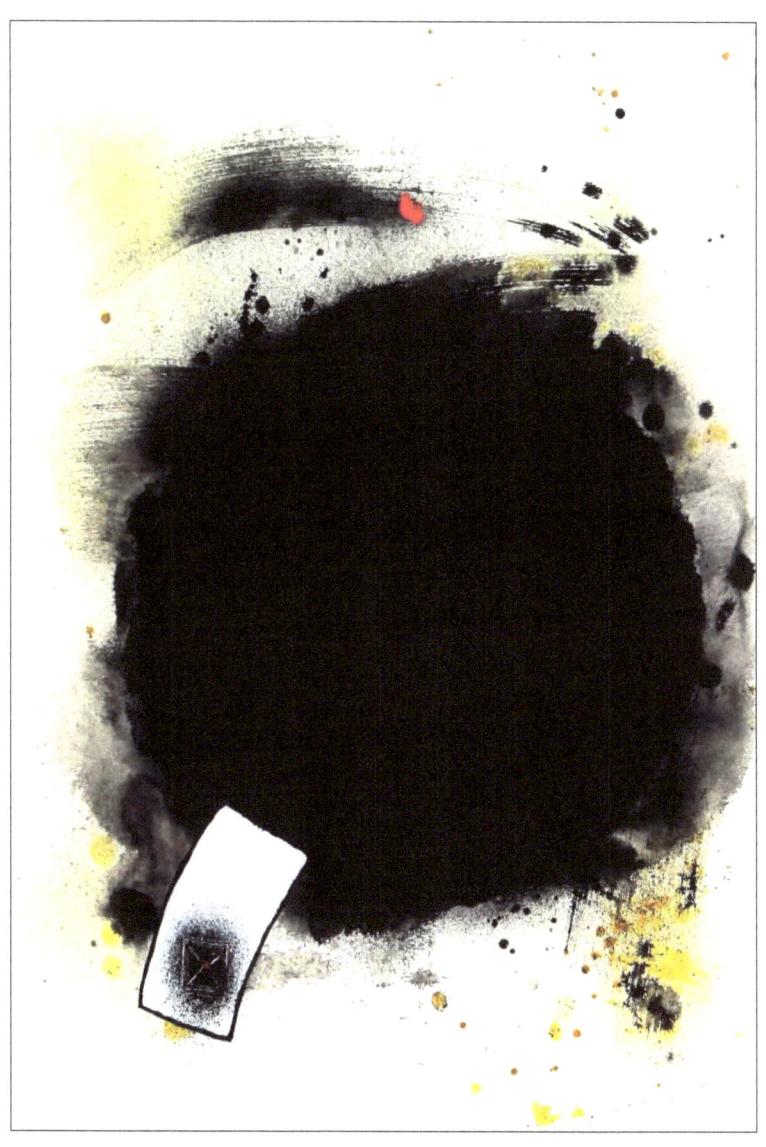

#1 July 2010.
Acrylic on paper, 44 x 30 inches.

Fred Martin, from Paintings and Notes 2010.

July 14, 2010.
Lac Ouareau, night.

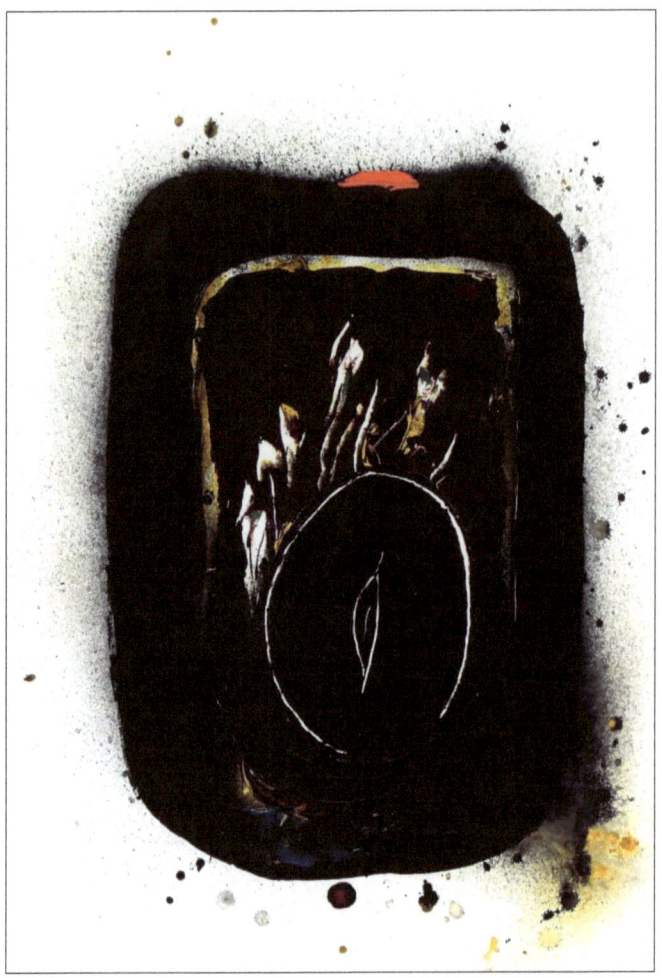

#3, July, 2010.
Acrylic on paper, 40 x 30 inches.

I heard…
"In the heads of old dry grass new seeds are always hidden."
This is my teaching career for the next years… and my art, too. Both are my life, old dry grass with next year's seeds in it. And as for the painting, I ended up with one very large seed.

Fred Martin, from Paintings and Notes 2010.

July 16, 2010.
Lac Ouareau, evening.

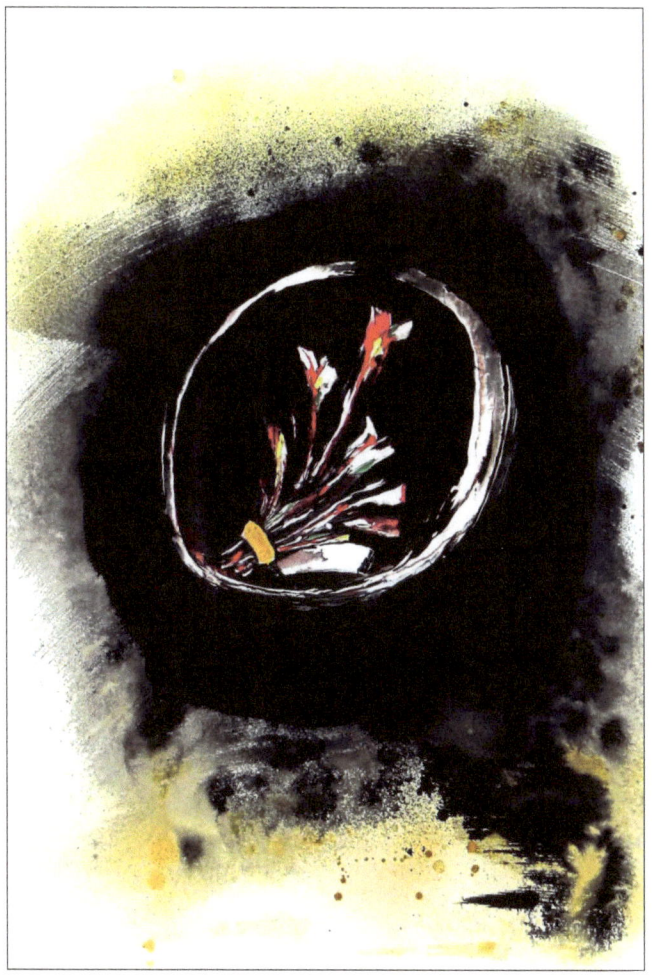

#4, July 2010.
Acrylic on paper, 40 x 30 inches.

Seeds sown become the child, sprout and then flower in maturity, are sown again by old age for the times to come. Sometimes in the flowering they bleed.

I wondered about putting in a white star for immortality, but noticed next day a random blot where it would have been—a black blot in a semi diamond shape—a death star. I didn't need to put it in, and it was not the trite immortality wish but the trite true fact of death after the flowers bleed.

Fred Martin, from Paintings and Notes 2010.

August 3, 2010.
Montreal, night.
These lines and scratches, smears and smudges,
Now and always the sharing of our immortality.

Every journey for each is different,
The last journey for each ends the same.

August 4, 2010.
Lac Ouareau, late afternoon.
Begin a diptych: two clichés.

#1 August 2010.
Conceived as a diptych, with the August 3 "life" text on the right and the "death" text on the left.

Night.
Trying to put the texts in and making notes of what they really mean...

> "These lines and scratches, smears and smudges,
> now and always the sharing of our immortality."

That is to say, my kinesthesis making them now, enters your kinesthesis whenever in the future (a thousand years?) you see them. We pass sooner, the object of art lasts longer.

> "Every journey for each is different,
> The last journey for each ends the same."

That is to say, we are all different but at the end we're all gone.

August 5, 2010.
Lac Ouareau, late late night (it's 2am of tomorrow).
More looking and working on *#1 August*—
I heard and did...
"Oh, Jesus, put the sperm spiral in the center, where it always only is for all of life/death and hereafter."

August 6, 2010.
Lac Ouareau, late afternoon.
For *#1 August*, put the red dot center bottom.

Night.
For *#1 August*, put the green dot center top.

Fred Martin, from Paintings and Notes 2010.

August 7, 2010
Lac Ouareau, afternoon.

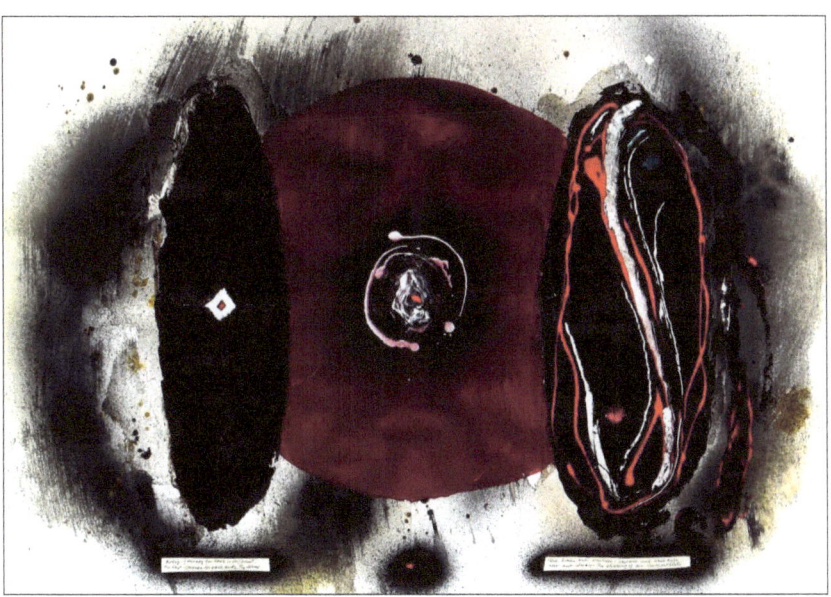

#1August 2010.
Acrylic on paper, 30 x 44 inches.

Looking at *#1 August*, it is such firm prose.
Except where the gray spray on the left should have been darker. So, on the death side, there's a formal error, an unbalance in a symmetrical composition… a void there on the left (the death side), none on the right (the life side). And, death is that. Look into it, the void on the left. How clearly unclear it is, the hole back into death the unknown.

Fred Martin, from Paintings and Notes 2010.

August 19, 2010.
Lac Ouareau, afternoon.
I heard…
"Give it to me, give it to me," as a "begging the Lord".

August 20, 2010.
Lac Ouareau, afternoon.
Looking at *#6 August*, the empty space at the top? Leave it. It's that we as particulars cannot know of the origin beyond us.

Yes, in *#6 August* the beyond us is just empty paper with a few wrinkles.

Fred Martin, from Paintings and Notes 2010.

**August 19, 2010.
Lac Ouareau, afternoon.**

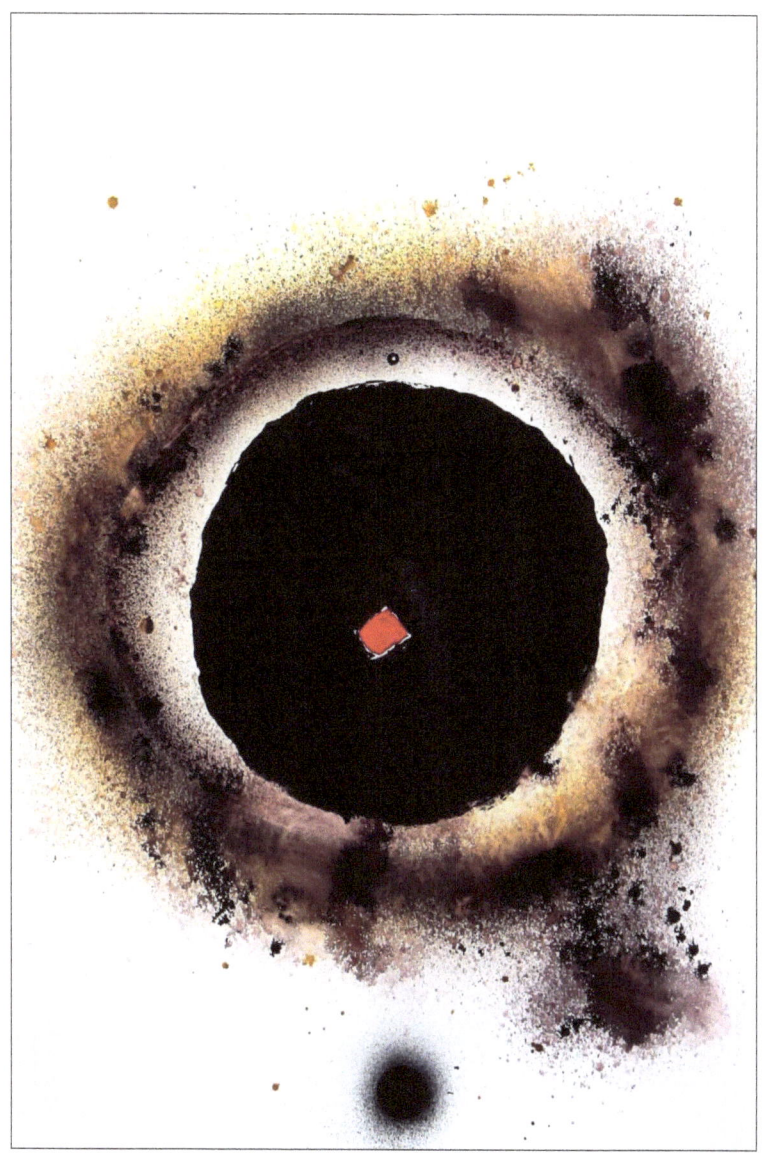

#6 August 2010.
Acrylic on paper, 44 x 30 inches.

Fred Martin, from Paintings and Notes 2010.

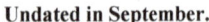

Undated in September.

#1 September 2010.
Acrylic on paper, 44 x 30 inches.

The dark is all the dust and nothing
our lives leave on the way to the horizon of death.

Fred Martin, from Paintings and Notes 2010.

Undated in September.

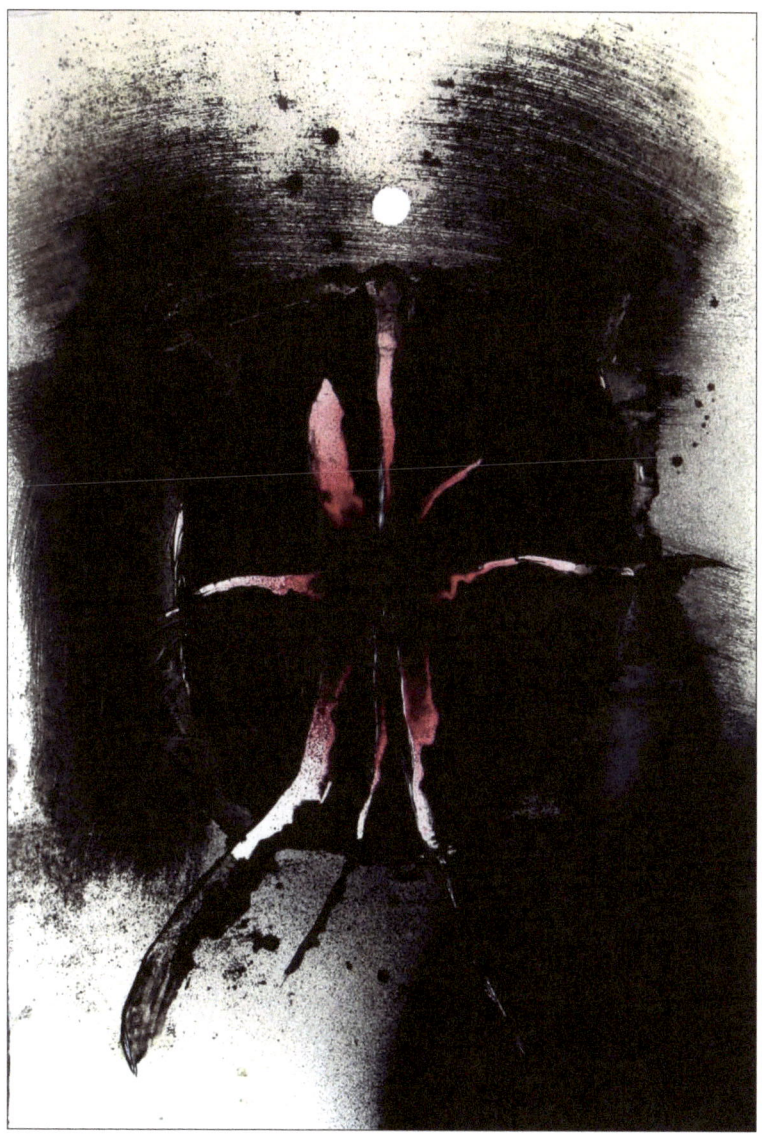

#2 September 2010.
Acrylic on paper, 44 x 30 inches

Smoldering, ever smoldering
caught between earth and sky
on a night of full moon.

Fred Martin, from Paintings and Notes 2010.

October 11, 2010.
Monte Vista studio, 1:11am.
Don't hold me, let me go. This art—whatever it is—shows the path.

October 12, 2010.
Monte Vista studio, very late night.
Work on *#1 October 2010,*
And see the autumn harvest that will not come again.

The altar in the studio is a table to hold the passing thoughts.

All things pass, none remain as they were. Every person of every generation sees and thinks differently. And so dear Fred, your work for forever is already gone when the first person sees it.

Make then for yourself the silence of your soul in the depth of night. Because for you that's all there is.

Even later night.
And this way is the only way to affirm my final solitude. Yes, alone, but what of the message to the world? See it and know. Read it and weep.

October 13, 2010.
Monte Vista house, so late it is tomorrow.
What matters most for an old man dying is to leave a trail in the dust to show the way. What pretension! And I'm not dying [yet]. Yet, we surely must—from every minute past birth we walk the trail to dying.

Yet I must say, my path is so different from the most of my time then to now and maybe after.

Even later
Of course always there's medium, skill, message and recipient…
For the people so long to come, how could I by then so long past have known their so long to come media of expression and ways of understanding?

Learn to live where and when you are…

Fred Martin, from Paintings and Notes 2010.

October 12, 2010.
Monte Vista studio, very late night.

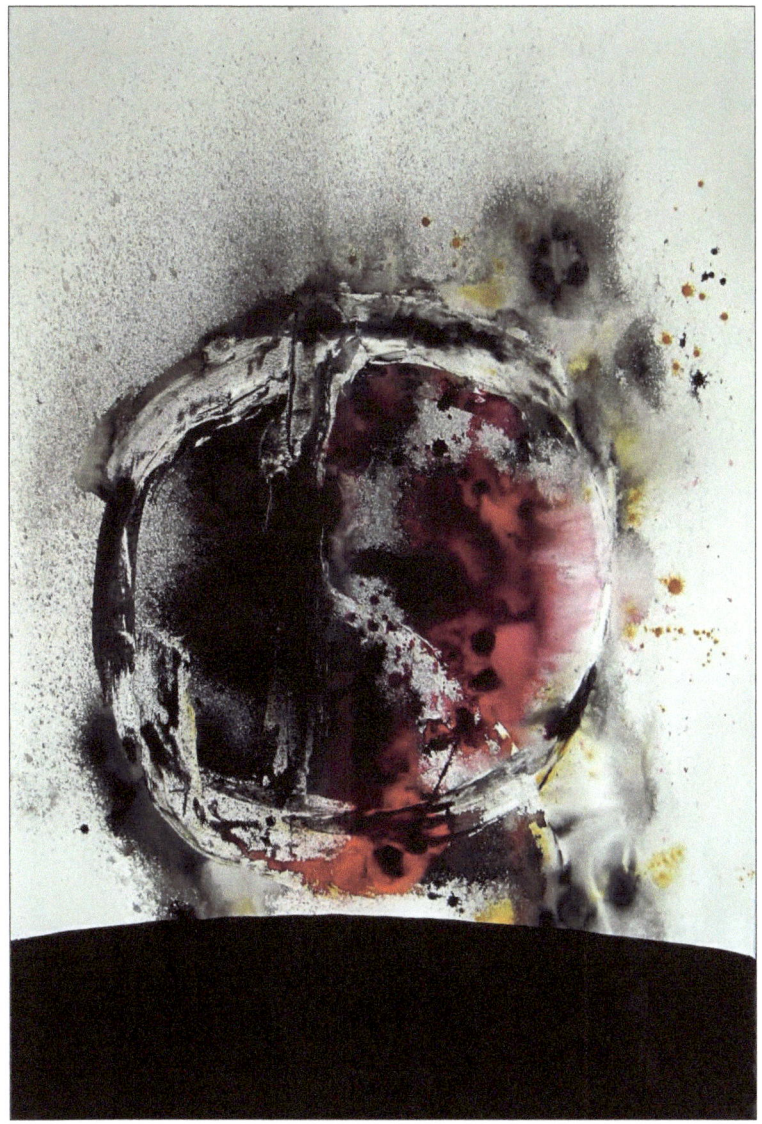

#1 October 2010.
Acrylic on paper, 44 x 30 inches.

Fred Martin, from Paintings and Notes 2010.

November 24, 2010.
Monte Vista studio, night.
What a hopeless position to be in—
I make something out of my experience for you to see in your experience, but we are totally different. The rationale is, see, I am crying; see, you are crying and neither of us knows why the other one cries. But my social role as artist is to make empty jugs for you to leave your tears.

November 25, 2010.
Monte Vista house, very early morning.
It is the guilt. That from the garret, even here now in the 21st Century, I have spent a lifetime luring students up here to where there is no passage out. Maybe at the turn of the 19th Century, maybe in the late 1940's- early 50's, maybe then there was a way out, but now surely not.

What is old age? When you know from the roots of your life that the parade has passed you by. There's left only some litter in the streets and a noise fading in the distance.

Lives now create only cartoons of what were the gods of our lives then.

That you have for most of a lifetime taught to the young what in old age you learn will be false for their time.

In our world, commodity rules. Know it. Live by fact, not fantasies of wish fulfillment. I cannot keep track of what everyone else says matters… only for me, what matters is the personal commitment, and that is "…until death do us part."

Fred Martin, from Paintings and Notes 2010.

November 17, 2010.
Monte Vista studio, dusk.

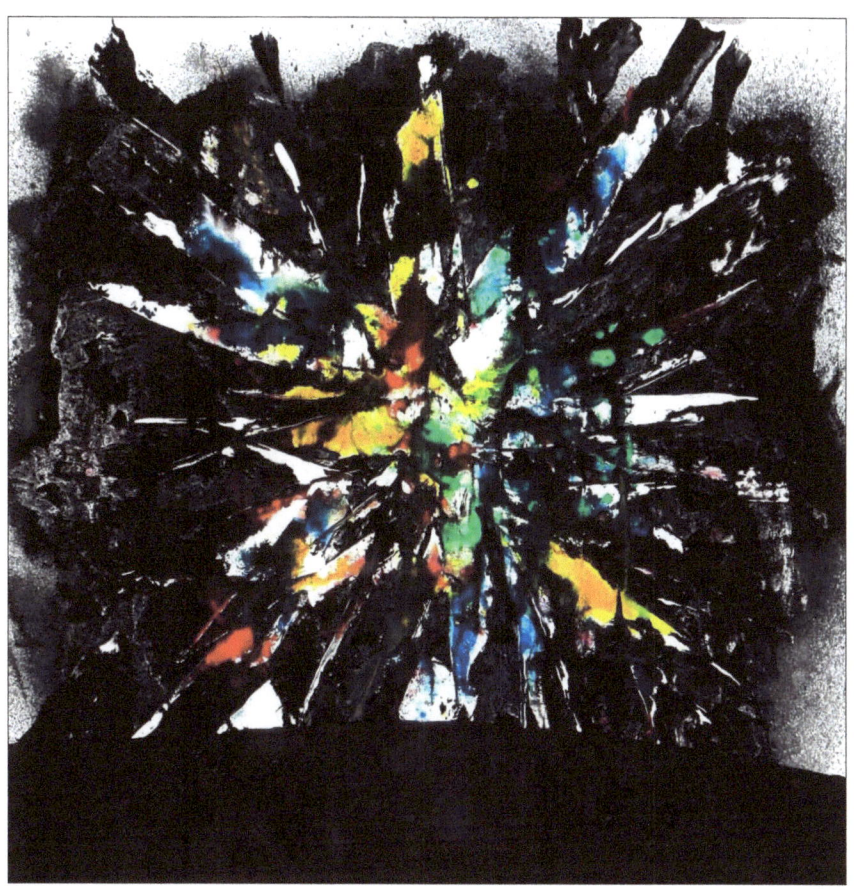

#1 November 2010.
Acrylic on paper, approx. 44 inches square.

About *#1, November*… "It is coming…"

Night
Looking at *#1 November* in its final form with the dark earth base, I heard, "A fragment of a faith affirmed."

Fred Martin, from Paintings and Notes 2010.

December 19, 2010.
Montreal, so late it's tomorrow.
Why does a painting matter in a museum? Because it is a milestone of the official history of art. Why does another work matter? Because it holds a part of the story of a soul. As an artist, which one do you want? (You probably can't have both.)

December 25, 2010.
Monte Vista, evening.
You don't want to see that, do you—
An old man groaning in the being of the grinding down of things

Very very late night.
And how to protect the psyche (soul) from the avalanche of "the media?" Remembering "Toward the Winter Solstice.." So far to go, so much is lost. But it's still here.

*

I must disconnect. The art world and my professional life all tell me what art is—but I must disconnect from them in order to know what the work must be for the last period of life.

December 29, 2010.
Montreal, 2nd Cup Coffee Shop.
While walking down the street to the coffee shop, I heard—
"That all the days of all the years are met in you each moment…"

- The death of a butterfly on Mars a hundred million years ago that never happened.
- The death of your grandmother a hundred years ago that did.
- The melting polar ice that's happening now.
- The cooling of the moon that's not.
- Your breathing and the vast turning of the spiral galaxy in Andromeda.
- What I think (and don't), and what they think (and don't).
- The slow drift of autumn afternoons into twilight (and yours).

All that vast shimmer of cause and effect in the infinite is met in you each moment of now and always.

Late night.
Yes, your task is to leave the story of the third phase of life—growing old.

SAY IT.

Fred Martin, from Paintings and Notes 2010.

December 27, 2010.
Monte Vista, noon.
I saw it last night, the circle of wholeness and the grid of knowledge.
They were ragged and smeared but still holding.

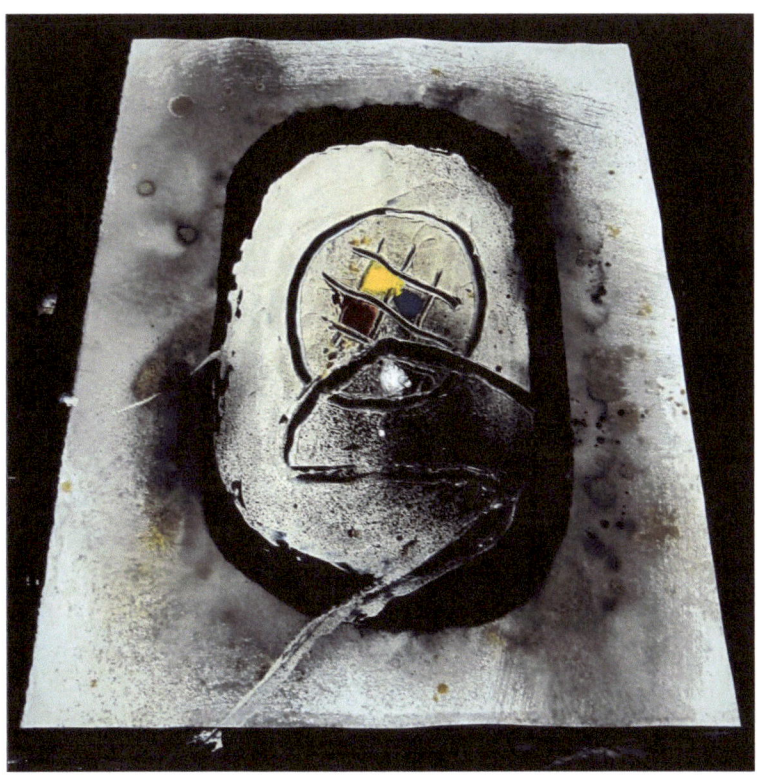

#2 December 2010.
Acrylic on paper, 40 x 27 inches.
(Photo made while painting still wet on the studio table.)

Night.
#2 December is called "Origin."
Tomorrow, look to see what came. What stays, stays.

(Tomorrow, it stayed.)

Fred Martin, from Paintings and Notes 2010.

January 6, 2011.
Lac Ouareau studio, morning.
#1 January 2011 says, "All ye know, and all ye need to know," remembered as the last line in Keats' *Ode on a Grecian Urn*.

Keats' poem began—

> Thou still unravish'd bride of quietness,
> Thou foster-child of Silence and slow Time,
> Sylvan historian, who canst thus express
> A flowery tale more sweetly than our rhyme:
> What leaf-fringed legend haunts about thy shape
> Of deities or mortals, or of both,
> In Tempe or the dales of Arcady?
> What men or gods are these? what maidens loth?
> What mad pursuit? What struggle to escape?
> What pipes and timbrels? What wild ecstasy?

And ended—

> O Attic shape! Fair attitude! with brede
> Of marble men and maidens overwrought,
> With forest branches and the trodden weed;
> Thou, silent form, dost tease us out of thought
> As doth eternity: Cold pastoral!
> When old age shall this generation waste,
> Thou shalt remain, in midst of other woe
> Than ours, a friend to man, to whom thou say'st,
> 'Beauty is truth, truth beauty'—that is all
> Ye know on earth, and all ye need to know.

Keats' Grecian urn said all we know and all we need to know on earth is that "Beauty is truth, truth beauty" in a "brede of marble men and maidens overwrought."

Here, all you know and all you need to know is that the black smear of the end will have always within it the tiny seed of life, the seed forever seeking the star of the Beyond.

Fred Martin, from Paintings and Notes 2010.

January 6, 2011.
Lac Ouareau studio, morning.

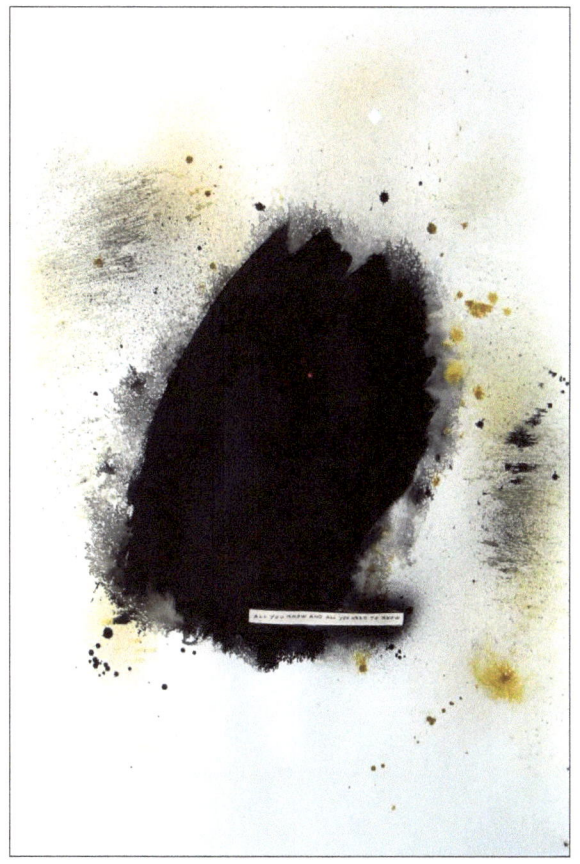

#1 January 2011.
Acrylic on paper with collage, 40 x 27 inches.

It says
"All ye know, and all ye need to know"

www.ingramcontent.com/pod-product-compliance
Lightning Source LLC
Chambersburg PA
CBHW041116180526
45172CB00001B/269